Super Simple HandLettering

20 TRACEABLE ALPHABETS, EASY PROJECTS, PRACTICE SHEETS & MORE!

T0386296

KILEY BENNETT

DESIGN ORIGINALS
an Imprint of Fox Chapel Publishing
www.d-originals.com

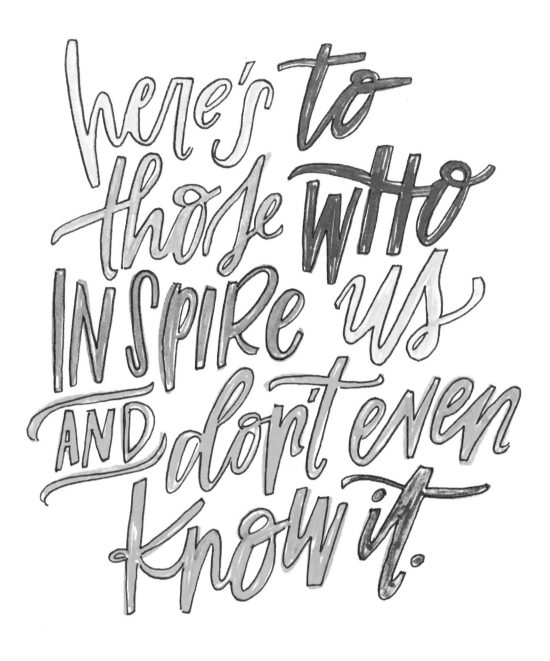

here's to those who inspire us and don't even know it.

ISBN 978-1-4972-0371-6

COPY PERMISSION: The written instructions, photographs, designs, patterns, and projects in this publication are intended for the personal use of the reader and may be reproduced for that purpose only. Any other use, especially commercial use, is forbidden under law without the written permission of the copyright holder. Every effort has been made to ensure that all information in this book is accurate. However, due to differing conditions, tools, and individual skills, neither the author nor publisher can be responsible for any injuries, losses, or other damages which may result from the use of the information in this book.
INFORMATION: All rights reserved. All images in this book have been reproduced with the knowledge and prior consent of the artists concerned and no responsibility is accepted by producer, publisher, or printer for any infringement of copyright or otherwise, arising from the contents of this publication. Every effort has been made to ensure that credits accurately comply with information supplied.
WARNING: Due to the components used in this craft, children under 8 years of age should not have access to materials or supplies without adult supervision. Under rare circumstances components of products could cause serious or fatal injury. Please read all safety warnings for the products being used. Neither New Design Originals, the product manufacturer, or the supplier is responsible.
NOTE: The use of products and trademark names is for informational purposes only, with no intention of infringement upon those trademarks.

© 2018 by Kiley Bennett and New Design Originals Corporation, *www.d-originals.com*, an imprint of Fox Chapel Publishing, 800-457-9112, 903 Square Street, Mount Joy, PA 17552.

We are always looking for talented authors. To submit an idea, please send a brief inquiry to acquisitions@foxchapelpublishing.com.

Printed in China
Fourth printing

About the Author

Kiley Bennett is the brush-lettering artist, teacher, and blogger behind Kiley in Kentucky (*www.kileyinkentucky.com*). In 2015, Kiley went out and purchased a couple of brush pens on her lunch break, and then spent the rest of the day lettering at her desk at work. Within a year, she was able to take her new business as a lettering artist full-time, and has since begun teaching online and in-person classes to students from around the world! Kiley and her husband, Daniel, live in Southern Illinois, where Kiley runs her business from their home with their cat, Beatrice, at her feet (or on top of her desk). They have every intention of moving back to their home state of Kentucky so Kiley can truly be "in Kentucky" once again.

Welcome

Hello, dear reader and soon-to-be-amazingly-talented-lettering-artist!

First of all, if you've opened this book—whether you are standing in the book store deciding whether to invest, or whether it was given to you as a gift by a very smart and fabulous loved one, or whether you ordered it for yourself because you want to learn lettering—you're making the first step. And the first step is always the hardest.

In this book, you'll find everything you need to know to get started in your lettering adventure. It includes information on the best tools (the ones I've been using since I started lettering), inspirational prints you can hang in your creative space, twenty traceable alphabets, and fun lettering projects you can dive into when your artistic confidence explodes!

The most important thing to do is to keep opening this book. Use this book as the tool that it is, but also draw inspiration from it. Remember that I was once where you are: reading a book about lettering and wishing I already knew what was inside. As long as you keep opening this book, you will learn, grow, and flourish in your lettering practice. I cannot wait to see where this artistic adventure will lead you!

Best wishes and happiest lettering,

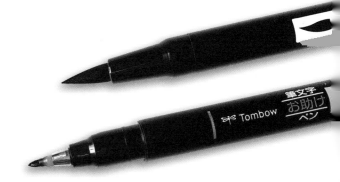

Creativity
is a muscle.
It gets stronger
=> with exercise.

Table OF Contents

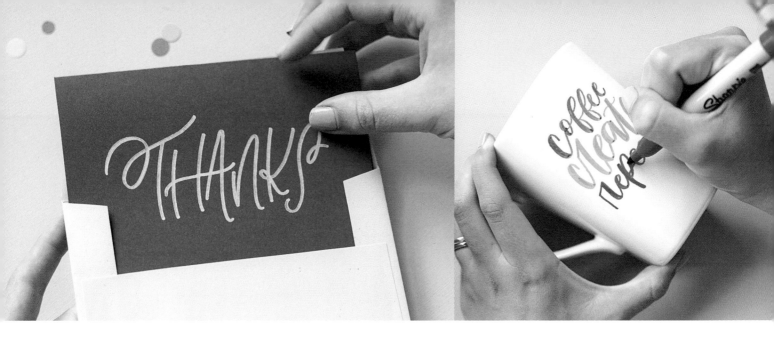

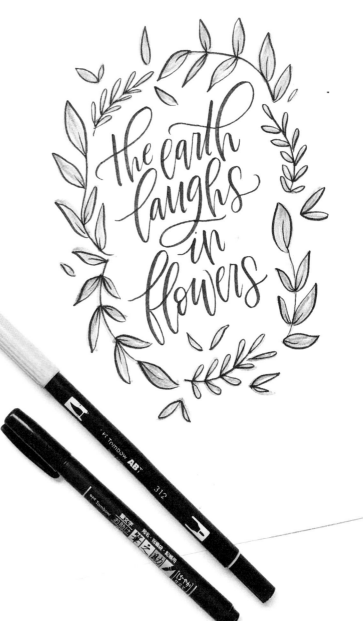

Getting Started

Before you go wild with a pen and paper, I want to teach you some hand lettering basics. This info will help you understand how lettering works—and is different from just handwriting—and get you familiar with the tools and features involved in hand lettering. You'll learn about different pens, nibs, and lettering styles, and then you'll be on your way to success!

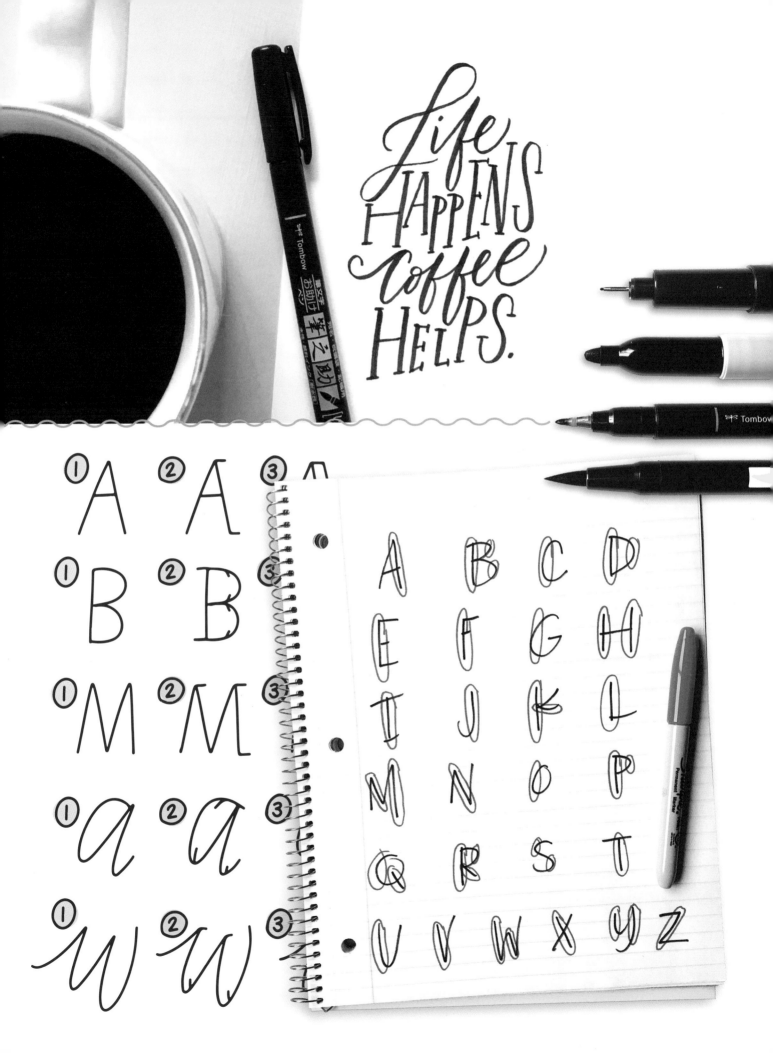

Suggested Tools & Materials

Before you can begin lettering, you'll need a few tools! These will become your best, most trusted friends throughout your lettering adventure. The tools pictured here will allow you to make four distinct lettering styles, all of which you will learn in this book: brush lettering, monoline lettering, faux calligraphy, and serif lettering.

These specific tools are simply a recommendation, not a requirement—but they *are* my favorites and what I'll be using throughout this book. However, these supplies come in a variety of brands and price ranges that will fit any budget. You are encouraged to letter in this book, as well as to use the tracing paper found in the back of the book, but you may find that you need extra paper as you work through the exercises. Both tracing paper and super-smooth cardstock can be found at any craft or art supply store, as well as at most big box supermarkets. Have a browse around, choose what brands and price points work best for you, and move forward with confidence!

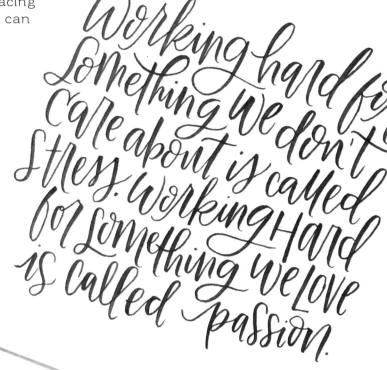

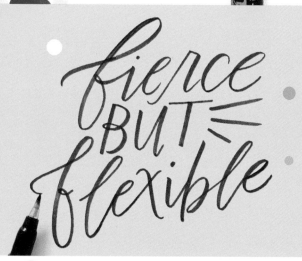

FOR YOUR REFERENCE, here are the particular products I usually use!

* Georgia-Pacific Bright White 110# Smooth Cardstock
* Artist's Loft Tracing Paper
* Tombow Dual Brush Pen in N15
* Tombow Fudenosuke Soft Tip
* Tombow Mono Drawing Pen in 01
* Sharpie Fine Point Marker
* Tombow Pencil Sharpener
* Tombow Dust Catch Eraser
* No. 2 Pencil

Super Smooth CARDSTOCK

tracing PAPER

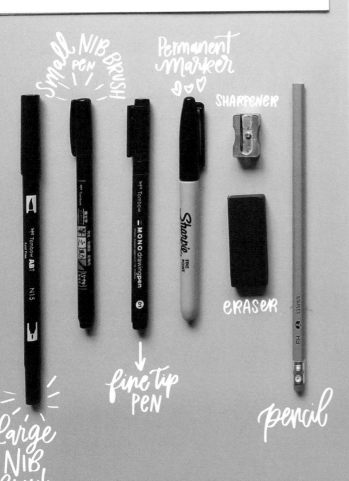

Small NIB PEN

NIB BRUSH

Permanent Marker

SHARPENER

eraser

fine tip PEN

pencil

Large NIB Brush PEN

What Is Hand Lettering, Anyway?

Hand lettering is the art of drawing fancy letters. There are various ways to go about hand lettering. You could use a basic quill pen and a pot of ink, a permanent marker like a Sharpie, or my personal favorite: a brush pen!

In this book, you'll be using four different pens to achieve various looks. What differentiates these pens from one another, making each one special and unique, is what we call the "nib." The nib is a fancy term for the tip of the pen. Most pens, like ballpoint or fine tip pens, have stiff nibs that create uniform lines. Those nibs are referred to as "monoline nibs."

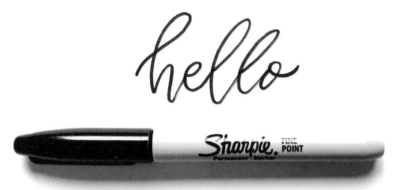

Monoline nib lettering

Other pens, like brush pens, have flexible nibs that bend with pressure. That's how brush pens create really beautiful letters with thick and thin strokes, making for eye-catching and impressive-looking lettering styles. Those nibs are called "brush nibs."

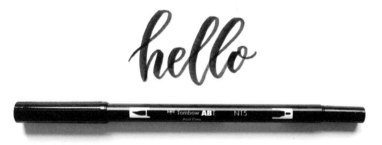

Brush nib lettering

You can also divide nibs by their size, small or large. So here are the four distinct nib types you'll want to get cozy with: large and small brush nibs and large and small monoline nibs.

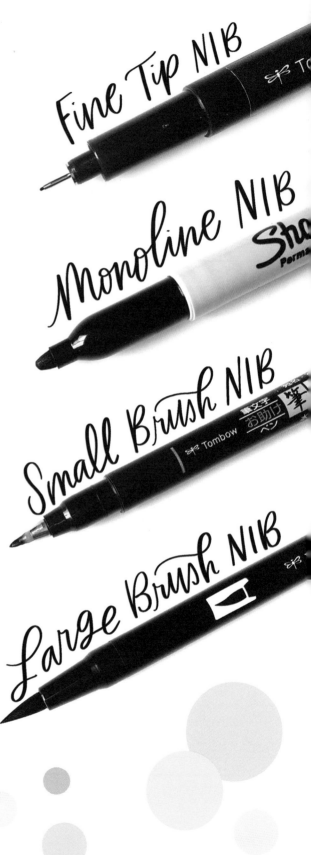

Fine Tip NIB

Monoline NIB

Small Brush NIB

Large Brush NIB

Using a Brush Pen

A brush pen is like any marker or ink pen except for its special, flexible nib that bends with a slight bit of pressure. The amount of pressure you use determines how thick your strokes will be. It's this flexibility that allows you to create beautiful **brush lettering**.

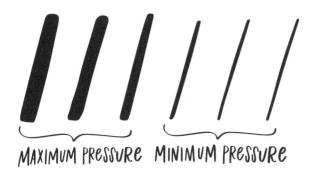

MAXIMUM PRESSURE MINIMUM PRESSURE

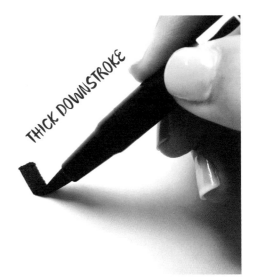

THICK DOWNSTROKE

A combination of thick and thin strokes in a single letter creates the dramatic brush-lettered look. But how do you know where to make your strokes thick and where to make them thin?

Easy peasy! Every time your pen moves down, or toward your body, you should apply lots of pressure—press hard—to create a thick downstroke.

Every time your pen moves up, or away from your body, you should apply no extra pressure; just use the pointy tip of the pen to create a thin line for your upstroke.

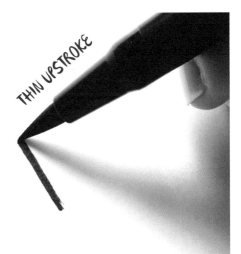

THIN UPSTROKE

Depending on the size of the brush pen you're using (whether it's large or small), your different strokes will look more dramatic or more understated.

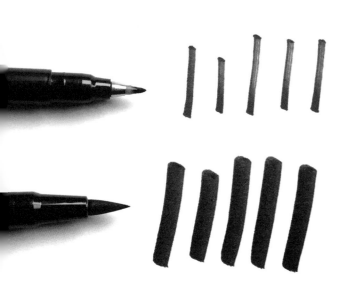

The top row of downstrokes in this image was created with a small brush pen. The bottom row of downstrokes was created with a large brush pen. See the difference?

But don't let the idea of downstrokes and upstrokes confuse or frustrate you! You make both of these strokes in your everyday handwriting with every letter and word you write. When hand lettering, your downstrokes and upstrokes should be where you *naturally* write.

TRY THIS!

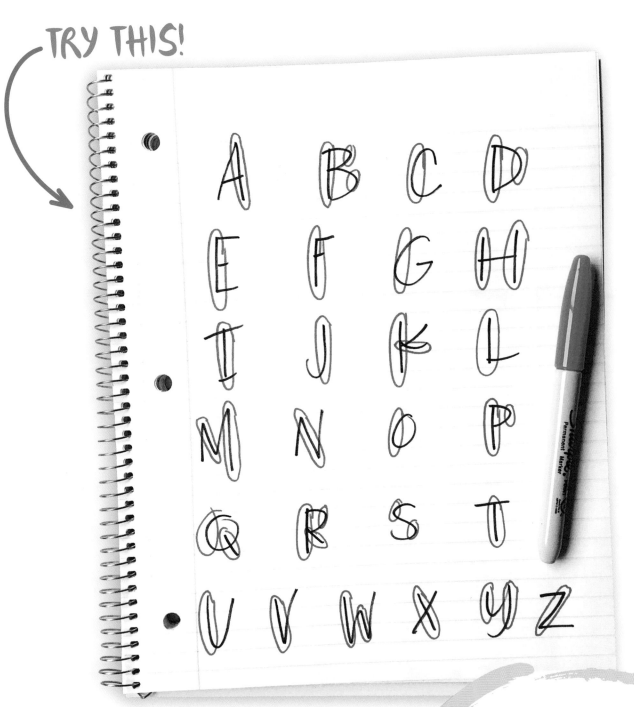

Here is a **quick exercise** for you to try! Grab a scrap sheet of paper and a pen or pencil. Write the alphabet. Be aware of every time your pencil moves up, making an upstroke, and every time your pencil moves down, making a downstroke. Now circle your downstrokes (you can do this all at once at the end, or as you finish each letter). The circled downstrokes are the important ones to remember.

Now that you are familiar with downstrokes and upstrokes, let's start practicing! Get out a small brush pen and a large brush pen and trace over the prompts on page 15, matching your stroke thicknesses to what I have done.

REMEMBER:
Apply lots of pressure when the pen is coming down/toward your body, and barely tickle the page, applying no extra pressure, when the pen is moving up/away from your body.

Trace these strokes!
LARGE BRUSH PEN WARM-UP

SMALL BRUSH PEN WARM-UP

KEEP PRACTICING!

Grab a sheet of tracing paper from the back of this book, place it on top of this page,
and continue tracing the warm-up strokes until you feel confident.

Using a Monoline Pen

Unlike a brush pen, a monoline pen creates uniform lines. At first glance, that might seem boring, but it's not to you, the aspiring lettering artist! There are three types of lettering styles you can create with monoline pens. All of the styles are fun, playful, and, best of all, super simple to achieve!

Monoline Lettering AND Faux Calligraphy

Monoline lettering is as simple as it sounds. Grab your standard size or fine tip monoline pen and simply start writing letters. But, if you find your own handwriting to be a bit boring, grab a piece of tracing paper and trace over any and all of the twenty diverse alphabets in this book. All it takes to achieve adorable monoline lettering are some extra-jazzy letters! (If you choose to trace a non-monoline alphabet, the monoline result might not match the original alphabet perfectly—but you might like the result!)

Make Today Awesome

These monoline letters were inspired by Alphabet 13 (see page 76).

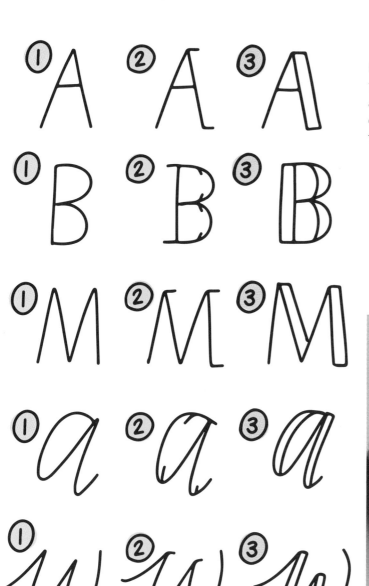

Faux calligraphy takes a bit of thought, but the result is impressive. It mimics brush lettering almost exactly, and that's why it's called *faux calligraphy*. There are three simple steps to follow when creating letters in this style:

1 Draw the letter as you would normally.

2 On the downstroke, mark where you will thicken the line with little notches, as pictured.

3 Connect the notches, completing the letter.

This is the same lettering with the faux calligraphy effect added! I filled in my downstrokes to create a solid look.

Serif lettering is super easy to create, too—you simply add notches to the pointy ends of your letters!

THeSe LiTtLe LiNes MaKe A BiG DiFfeReNCe!

This time, I added serif notches to my letters to take them up a notch!

Gallery

Here's a peek at just some of the possibilities that await you in your hand lettering adventure! I hope this gallery will inspire you to experiment with different layouts, lettering styles, and images. Remember: none of these examples took me long to do, so they are totally achievable for you, too!

◀ I added shadows to these letters with a gray brush pen.

Be careful how you talk to yourself. you are Listening

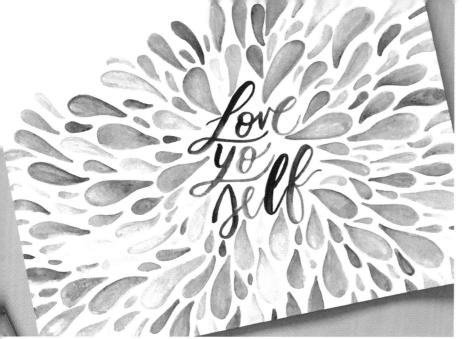

Love yo self

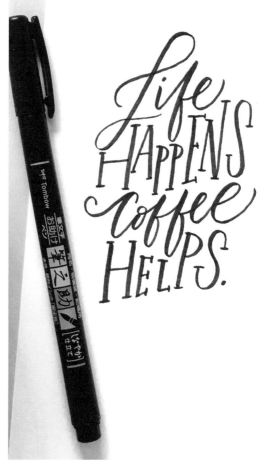

Life HAPPENS coffee HELPS.

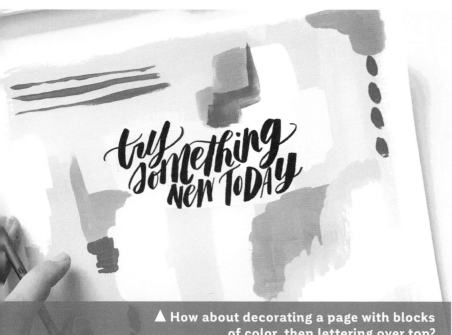

try something new today

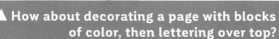

▲ How about decorating a page with blocks of color, then lettering over top?

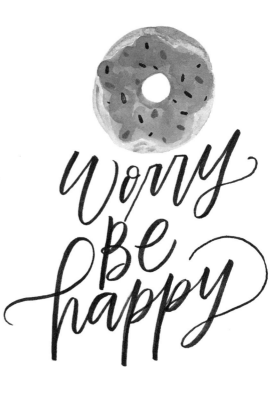

Worry Be happy

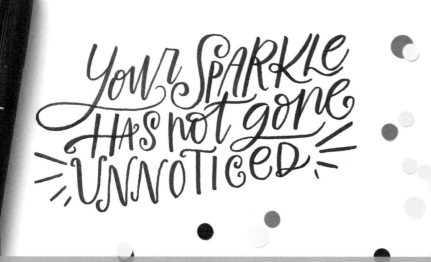

Your SPARKLE HAS not gone UNNOTICED

▲ Choose a focal word and letter it a little differently from the rest to make it stand out.

You can do HARD things & do them WELL.

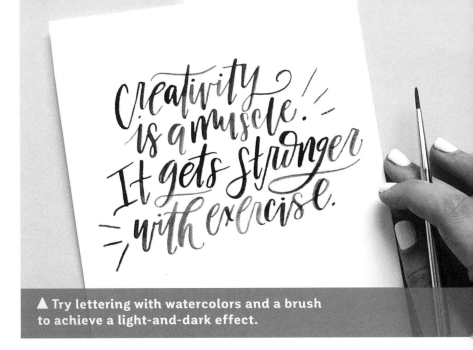

▲ Try lettering with watercolors and a brush to achieve a light-and-dark effect.

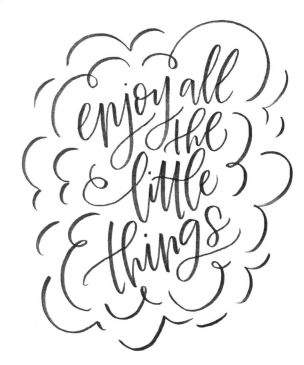

enjoy all the little things

Working hard for something we don't care about is called stress. Working HARD for something we LOVE is called passion.

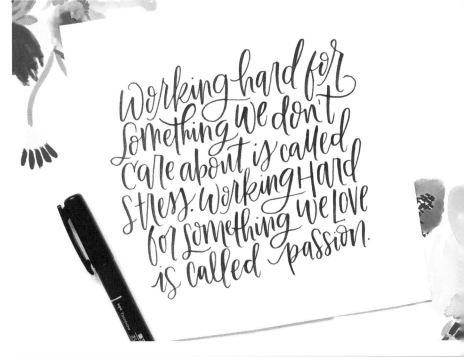

▼ Try lettering with multicolor watercolors!

▲ You can decorate lettering with simple strokes like these puffy "clouds."

MAMA didn't raise NO FOOL

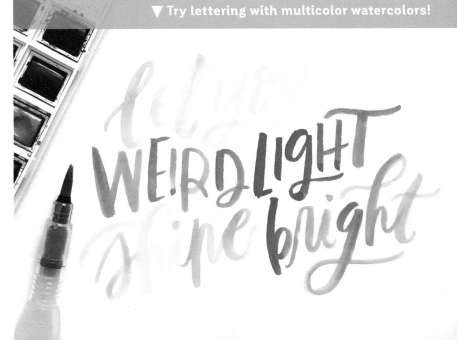

WE!RD LIGHT bright

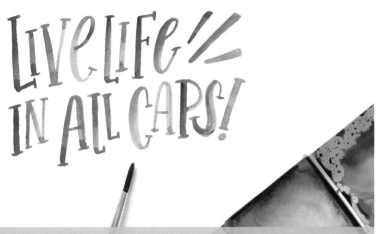

LIVE LIFE//
IN ALL CAPS!

▲ This watercolor phrase uses two tones of blue for a colorful! but cohesive effect.

put your
POSITIVE
pants on

▼ Rainbow letters sing loud!

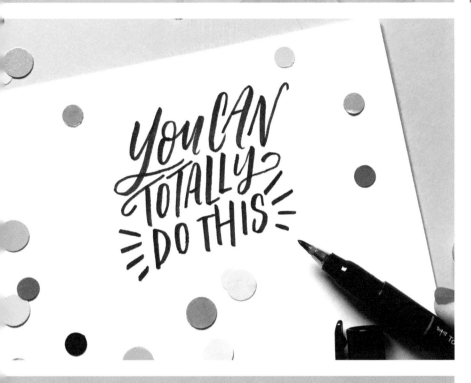

You CAN
TOTALLY
DO THIS

here's to
those WHO
INSPIRE us
AND don't even
know it.

▼ Try building this 3D effect.

grow through
what you
go through

"Some days
I'm just ON
FIRE. What can
I say? MICHAEL
SCOTT."

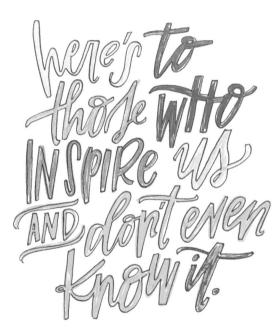

MONO drawingpen 01
Tombow Water-based pigment ink marker

THE Alphabets

Here we go: it's the moment you've been waiting for! In this section you'll find twenty totally different alphabets to mix and match, practice, experiment with, and enjoy. There are brush-lettering alphabets and monoline alphabets, simple alphabets and complex alphabets, curly, curvy, straight, thick, thin, and every-other-adjective-you-can-think-of alphabets!

Traceable! Each alphabet is first presented in a pure, traceable form in both uppercase and lowercase. Grab some tracing paper from the back of the book and start tracing to get a feel for the alphabet.

Fun uses! Each alphabet also has some fun suggested uses for ways and places to try it out!

Alphabet 15 Uppercase

START TRACING!

Try this snazzy alphabet on:
- ENVELOPES
- CHALKBOARD
- MENU SIGNS
- SIMPLE THANK YOU NOTES

A B C D E F
G H I J K L
M N O P Q R
S T U V W
X Y Z

Alphabet 15 Lowercase

START TRACING!

a b c d e f
g h i j k l
m n o p q
r s t u v
w x y z

The Alphabets

Draw Your Own!

A _ B _ C _ D _ E _
F _ G _ H _ I _ J _ K _
L _ M _ N _ O _ P
Q _ R _ S _ T _ U
V _ W _ X _ Y _ Z

Draw Your Own!

a _ b _ c _ d _ e _
f _ g _ h _ i _ j _ k
l _ m _ n _ o _ p _
q _ r _ s _ t _ u _
v _ w _ x _ y _ z _

Practice! Each alphabet is broken down into strokes so you can see how each letter is actually written. Practice imitating each letter one at a time, following the stroke guide.

PRACTICE EXERCISE 3

ADD A *Flourish*

Add a fancy flair to any letter with a flourish! Want proof?

A → AB Y → Ye

Trace these flourishes...

Super Simple Hand Lettering

Now make these letters FANCY with some flourishes:

j n b c
l m g
e h m v
q t u

Exercise! There are also four interesting practice exercises you can try mixed in with the alphabets. Use them to broaden the scope of your lettering abilities and imagination!

The Alphabets

Alphabet 1 Uppercase

START
TRACING!
↓

Try this simple
alphabet on:

- NAMETAGS
- ANNOUNCEMENTS
- GIFTS
FOR TEACHERS
- ENVELOPES

A B C D E F

G H I J K L

M N O P Q R

S T U V W

X Y Z

Alphabet 1 Lowercase

START
TRACING!
↓

a b c d e f

g h i j k l

m n o p q

r s t u v

w x y z

Draw Your Own!

A___ B___ C___ D___ E___

F___ G___ H___ I___ J___ K___

L___ M___ N___ O___ P___

Q___ R___ S___ T___ U___

V___ W___ X___ Y___ Z___

Draw Your Own!

a _ b _ c _ d _ e _

f _ g _ h _ i _ j _ k _

l _ m _ n _ o _ p _

q _ r _ s _ t _ u _

v _ w _ x _ y _ z _

Alphabet 2 Uppercase

START TRACING!
↓

Try this stretched
alphabet on:

- QUIRKY BIRTHDAY
 INVITATIONS
- FUN THANK YOU
 NOTES
- HAND-LETTERED
 PRINTS
- CHALKBOARDS

A B C D E F

G H I J K L

M N O P Q

R S T U V

W X Y Z

Alphabet 2 Lowercase

START
TRACING!
↓

a b c d e f

g h i j k l

m n o p q

r s t u v

w x y z

Draw Your Own!

A _ B _ C _ D _ E _

F _ G _ H _ I _ J _ K _

L _ M _ N _ O _ P _

Q _ R _ S _ T _ U _

V _ W _ X _ Y _ Z _

Draw Your Own!

a _ b _ c _ d _ e _

f _ g _ h _ i _ j _ k _

l _ m _ n _ o _ p _

q _ r _ s _ t _ u _

v _ w _ x _ y _ z _

Alphabet 3 Uppercase

START TRACING!
↓

Try this quirky alphabet on:

- MUGS
- A PRETEEN'S BIRTHDAY INVITATIONS
- MODERN LETTERING PROJECTS
- CHALKBOARDS

A B C D E F
G H I J K L
M N O P Q
R S T U V
W X Y Z

Alphabet 3 Lowercase

START
TRACING!
↓

a b c d e f

g h i j k l

m n o p q

r s t u v

w x y z

Draw Your Own!

A _ B _ C _ D _ E _

F _ G _ H _ I _ J _ K _

L _ M _ N _ O _ P _

Q _ R _ S _ T _ U _

V _ W _ X _ Y _ Z _

Draw Your Own!

a — b — c — d — e —

f — g — h — i — j — k —

l — m — n — o — p —

q — r — s — t — u —

v — w — x — y — z —

Alphabet 4 Uppercase

Try this pretty
alphabet on:

- PLACE SETTINGS
- ENVELOPES
- MUGS
- NOTEBOOKS OR
 JOURNALS

START
TRACING!
↓

A B C D E F

G H I J K L

M N O P Q

R S T U V

W X Y Z

Alphabet 4 Lowercase

START
TRACING!
↓

a b c d e f

g h i j k l

m n o p q r

s t u v w

x y z

Draw Your Own!

A _ _ B _ _ C _ _ D _ _

E _ _ F _ _ G _ _ H _ _

l _ _ J _ _ K _ _ L _ _

M _ _ N _ _ O _ _ P _ _

Q _ _ R _ _ S _ _ T _ _ U _

V _ W _ _ X _ _ Y _ _ Z _

Draw Your Own!

a ___ b ___ c ___ d ___ e ___

f ___ g ___ h ___ i ___ j ___ k ___

l ___ m ___ n ___ o ___ p ___

q ___ r ___ s ___ t ___ u ___

v ___ w ___ x ___ y ___ z ___

Alphabet 5 Uppercase

START
TRACING!
↓

Try this jazzy
alphabet on:

- PARTY SIGNS
- ENVELOPES
- WEDDING OR EVENT
 MENUS
- SOPHISTICATED
 THANK YOU NOTES

A B C D E
F G H I J K
L M N O P
Q R S T U V
W X Y Z

Alphabet 5 Lowercase

START TRACING!
↓

a b c d e f

g h i j k l

m n o p q

n s t u v

w x y z

Draw Your Own!

A ___ B ___ C ___ D ___

E ___ F ___ G ___ H ___

I ___ J ___ K ___ L ___

M ___ N ___ O ___ P ___

Q ___ R ___ S ___ T ___ U ___

V ___ W ___ X ___ Y ___ Z ___

Draw Your Own!

a _ b _ c _ d _ e _

f _ g _ h _ i _ j _ k _

l _ m _ n _ o _ p _

q _ r _ s _ t _ u _

v _ w _ x _ y _ z _

MAKE IT A SERIF
This → This

↓TRACE THIS↓

Practice here A B C A B C

FINISH THIS LINE! A B C A B C

NOW, TRY YOUR OWN!

See page 17 for more info on serif letters!

Practice here

Alphabet 6 Uppercase

START TRACING!
↓

Try this girly
alphabet on:

- BIRTHDAY
 INVITATIONS
- CHALKBOARDS
- NOTEBOOKS OR
 JOURNALS
- MUGS

A B C D E F

G H I J K L

M N O P Q

R S T U V

W X Y Z

Alphabet 6 Lowercase

START
TRACING!
↓

a b c d e f

g h i j k l

m n o p q

r s t u v

w x y z

Draw Your Own!

A __ B __ C __ D __ E __

F __ G __ H __ I __ J __

K __ L __ M __ N __

O __ P __ Q __ R __ S __

T __ U __ V __ W __

X __ Y __ Z __

Draw Your Own!

a __ b __ c __ d __ e __

f __ g __ h __ i __ j __ k __

l __ m __ n __ o __ p __

q __ r __ s __ t __ u __

v __ w __ x __ y __ z __

Alphabet 7 Uppercase

START TRACING!
↓

Try this edgy
alphabet on:

- MORE MASCULINE
 PROJECTS
- COOL THANK YOU
 NOTES
- PHOTO FRAME MATS
- LOGO DESIGNS

A B C D E
F G H I J
K L M N O
P Q R S
T U V W
X Y Z

Alphabet 7 Lowercase

START
TRACING!
↓

a b c d e

f g h i j k

l m n o p

q r s t u v

w x y z

Draw Your Own!

A ____ B ____ C ____

D ____ E ____ F ____ G ____

H ____ I ____ J ____ K ____

L ____ M ____ N ____ O ____

P ____ Q ____ R ____ S ____

T ____ U ____ V ____ W ____

X ____ Y ____ Z ____

Draw Your Own!

a ____ b ____ c ____

d ____ e ____ f ____ g ____

h ____ i ____ j ____ k ____

l ____ m ____ n ____ o ____

p ____ q ____ r ____ s ____

t ____ u ____ v ____ w ____

x ____ y ____ z ____

Alphabet 8 Uppercase

START TRACING! ↓

Try this bubbly
alphabet on:

- A GIFT FOR A
 LITTLE GIRL
- BIRTHDAY
 INVITATIONS
- THANK YOU NOTES
- PARTY SIGNS

A B C D E
F G H I J
K L M N O
P Q R S
T U V W
X Y Z

Alphabet 8 Lowercase

START TRACING! ↓

a b c d e

f g h i j k

l m n o p

q r s t u v

w x y z

Draw Your Own!

A _ B _ C _

D _ E _ F _ G _

H _ I _ J _ K _

L _ M _ N _ O _

P _ Q _ R _ S _

T _ U _ V _ W _

X _ Y _ Z _

Draw Your Own!

a ___ b ___ c ___

d ___ e ___ f ___ g ___

h ___ i ___ j ___ k ___

l ___ m ___ n ___ o ___

p ___ q ___ r ___ s ___

t ___ u ___ v ___ w ___

x ___ y ___ z ___

Alphabet 9 Uppercase

Try this scripty
alphabet on:

- WEDDING
 INVITATIONS
- ENVELOPES
- THANK YOU NOTES
- NOTEBOOKS
 OR JOURNALS

START
TRACING!
↓

A B C D E F
G H I J K L
M N O P Q
R S T U V
W X Y Z

Alphabet 9 Lowercase

START
TRACING!
↓

a b c d e f

g h i j k l

m m o p q r

s t u n n

x y z

Draw Your Own!

A _ B _ C _ D _

E _ F _ G _ H _

d _ J _ K _ L _

M _ N _ O _ P _

Q _ R _ S _ T _ U _

N _ M _ X _ Y _ Z _

Draw Your Own!

a ____ b ____ c ____ d ____ e ____

f ____ g ____ h ____ i ____ j ____ k ____

l ____ m ____ n ____ o ____ p ____

q ____ r ____ s ____ t ____ u ____

v ____ w ____ x ____ y ____ z ____

Alphabet 10 Uppercase

START TRACING!
↓

Try this hip alphabet on:

- MORE MASCULINE PROJECTS
- SIMPLE THANK YOU NOTES
- MENU SIGNS
- PHOTO FRAME MATS

A B C D E F

G H I J K L

M N O P Q

R S T U V

W X Y Z

Alphabet 10 Lowercase

START TRACING! ↓

a b c d e f

g h i j k l

m n o p q

r s t u v

u x y z

Draw Your Own!

A ___ B ___ C ___ D ___

E ___ F ___ G ___ H ___

I ___ J ___ K ___ L ___

M ___ N ___ O ___ P ___

Q ___ R ___ S ___ T ___

U ___ V ___ W ___ X ___

Y ___ Z ___

Draw Your Own!

a _ b _ c _ d _ e _

f _ g _ h _ i _ j _

k _ l _ m _ n _ o _

p _ q _ r _ s _ t _

u _ v _ w _ x _

y _ z _

MIX 'n' Match

Pairing a plain font with a scripty style can take your design up a notch!

A simple phrase....

OH happy DAY

Or a friend's address...

VALERIE FROST
425 Happy Valley Rd
HAPPYVILLE, Kentucky
0 1 2 3 4

Address your own envelope using a mix 'n' match style!

Alphabet II Uppercase

Try this swirly
alphabet on:

- BIRTHDAY
 INVITATIONS
- CHALKBOARDS
- MUGS
- PLACE SETTINGS

START
TRACING!
↓

A B C D E
F G H I J
K L M N O
P Q R S
T U V W
X Y Z

Alphabet II Lowercase

START
TRACING!
↓

a b c d e

f g h i j k

l m n o p

q r s t u v

w x y z

Draw Your Own!

A _ B _ C _

D _ E _ F _ G _

H _ I _ J _ K _

L _ M _ N _ O _

P _ Q _ R _ S _

T _ U _ V _ W _

X _ Y _ Z _

Draw Your Own!

a ___ b ___ c ___

d ___ e ___ f ___ g ___

h ___ i ___ j ___ k ___

l ___ m ___ n ___ o ___

p ___ q ___ r ___ s ___

t ___ u ___ v ___ w ___

x ___ y ___ z ___

Alphabet 12 Uppercase

START TRACING!
↓

Try this sophisticated alphabet on:

- BIRTHDAY INVITATIONS
- BIBLE VERSE LETTERING
- MUGS
- PRETTY BIRTHDAY CARDS

A B C D E
F G H I J
K L M N O
P Q R S
T U V W
X Y Z

Alphabet 12 Lowercase

START
TRACING!
↓

a b c d e
f g h i j k
l m n o p
q r s t u v
w x y z

Draw Your Own!

A___ B___ C___

D___ E___ F___ G___

H___ I___ J___ K___

L___ M___ N___ O___

P___ Q___ R___ S___

T___ U___ V___ W___

X___ Y___ Z___

Draw Your Own!

a _____ b _____ c _____

d _____ e _____ f _____ g _____

h _____ i _____ j _____ k _____

l _____ m _____ n _____ o _____

p _____ q _____ r _____ s _____

t _____ u _____ v _____ w _____

x _____ y _____ z _____

Alphabet 13 Uppercase

START
TRACING!
↓

Try this fancy
alphabet on:

- ENVELOPES
- PARTY INVITATIONS
- LOGO DESIGNS
- CHALKBOARDS

A B C D E F
G H I J K L
M N O P Q
R S T U V
W X Y Z

Alphabet 13 Lowercase

START
TRACING!
↓

a b c d e f

g h i j k l

m n o p q

r s t u v

w x y z

Draw Your Own!

A _ B _ C _ D _

E _ F _ G _ H _ I _

J _ K _ L _ M _ N _

O _ P _ Q _ R _ S _

T _ U _ V _ W _ X _

Y _ Z _

Draw Your Own!

a ___ b ___ c ___ d ___ e ___

f ___ g ___ h ___ i ___ j ___

k ___ l ___ m ___ n ___ o ___

p ___ q ___ u ___ s ___ t ___

u ___ v ___ w ___ x ___

y ___ z ___

Alphabet 14 Uppercase

START
TRACING!
↓

Try this bold
alphabet on:

- NOTEBOOKS OR
 JOURNALS
- THANK YOU NOTES
- WEDDING OR
 EVENT MENUS
- MUGS

A B C D E F

G H I J K L

M N O P Q

R S T U V

W X Y Z

Alphabet 14 Lowercase

START
TRACING!
↓

a b c d e f

g h i j k l

m n o p q

r s t u v

w x y z

Draw Your Own!

\mathcal{A} ___ \mathcal{B} ___ \mathcal{C} ___ \mathcal{D} ___

\mathcal{E} ___ \mathcal{F} ___ \mathcal{G} ___ \mathcal{H} ___

\mathcal{I} ___ \mathcal{J} ___ \mathcal{K} ___ \mathcal{L} ___

\mathcal{M} ___ \mathcal{N} ___ \mathcal{O} ___ \mathcal{P} ___

\mathcal{Q} ___ \mathcal{R} ___ \mathcal{S} ___ \mathcal{T} ___

\mathcal{U} ___ \mathcal{V} ___ \mathcal{W} ___ \mathcal{X} ___

\mathcal{Y} ___ \mathcal{Z} ___

Draw Your Own!

a ___ b ___ c ___ d ___ e ___

f ___ g ___ h ___ i ___ j ___

k ___ l ___ m ___ n ___ o ___

p ___ q ___ r ___ s ___ t ___

u ___ v ___ w ___ x ___

y ___ z ___

Alphabet 15 Uppercase

Try this snazzy
alphabet on:

- ENVELOPES
- CHALKBOARD
- MENU SIGNS
- SIMPLE THANK
 YOU NOTES

START
TRACING!
↓

A B C D E F
G H I J K L
M N O P Q R
S T U V W
X Y Z

Alphabet 15 Lowercase

START
TRACING!
↓

a b c d e f

g h i j k l

m n o p q

r s t u v

w x y z

Draw Your Own!

A __ B __ C __ D __ E __

F __ G __ H __ I __ J __ K __

L __ M __ N __ O __ P __

Q __ R __ S __ T __ U __

V __ W __ X __ Y __ Z __

Draw Your Own!

a ___ b ___ c ___ d ___ e ___

f ___ g ___ h ___ i ___ j ___ k ___

l ___ m ___ n ___ o ___ p ___

q ___ r ___ s ___ t ___ u ___

v ___ w ___ x ___ y ___ z ___

Add a fancy flair to any letter with a flourish!
Want proof?

$A \overset{?}{\rightarrow} AB$ $Y \rightarrow Ye$

Trace these flourishes...

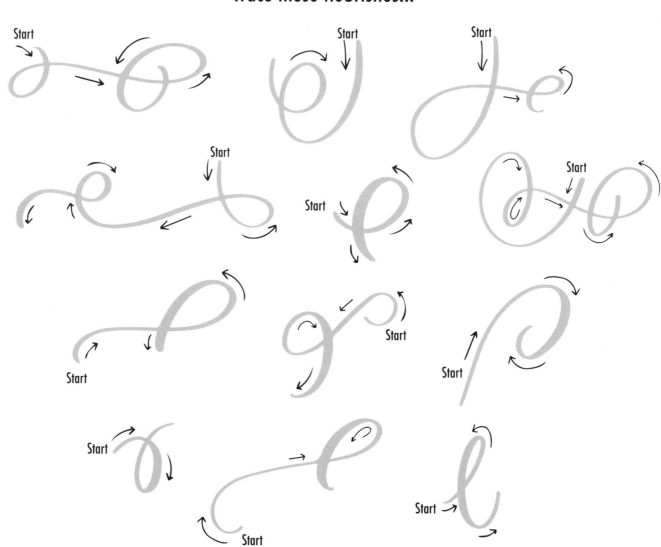

Now make these letters FANCY with some flourishes:

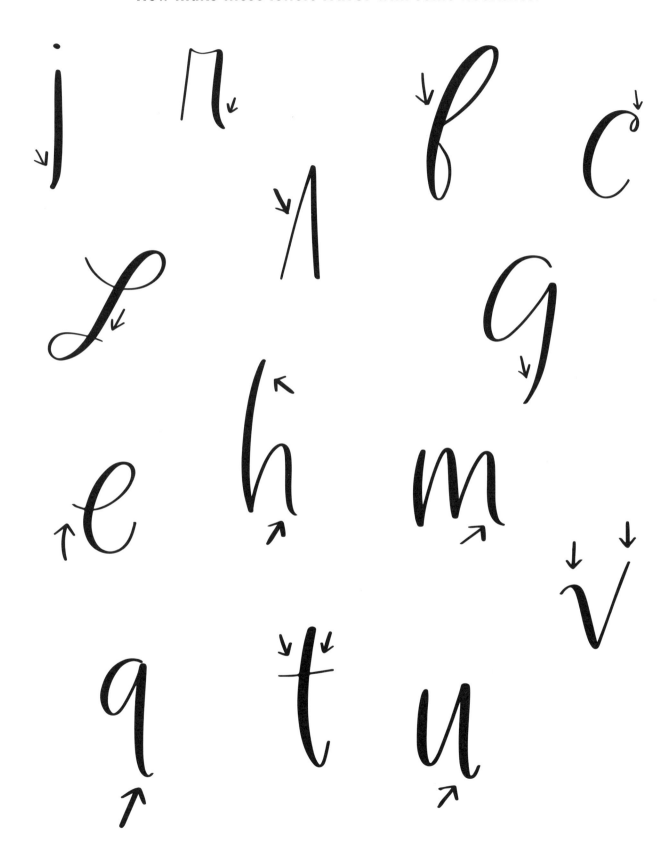

Alphabet 16 Uppercase

START TRACING! ↓

Try this loopy
alphabet on:

- LOGO DESIGNS
- MONOGRAMS
- THANK YOU NOTES
- BIBLE VERSE
 LETTERING

A B C D E F
G H I J K L
M N O P Q
R S T U V
W X Y Z

Alphabet 16 Lowercase

START TRACING!
↓

a b c d e

f g h i j

k l m n o p

q r s t u v

w x y z

Draw Your Own!

\mathcal{A} __ \mathcal{B} __ \mathcal{C} __ \mathcal{D} __ \mathcal{E} __

\mathcal{F} __ \mathcal{G} __ \mathcal{H} __ \mathcal{I} __ \mathcal{J} __ \mathcal{K} __

\mathcal{L} __ \mathcal{M} __ \mathcal{H} __ \mathcal{O} __ \mathcal{P} __

\mathcal{Q} __ \mathcal{R} __ \mathcal{S} __ \mathcal{T} __ \mathcal{U} __

\mathcal{V} __ \mathcal{W} __ \mathcal{X} __ \mathcal{Y} __ \mathcal{Z} __

Draw Your Own!

a ___ b ___ c ___ d ___ e ___

f ___ g ___ h ___ i ___ j ___ k ___

l ___ m ___ n ___ o ___ p ___

q ___ r ___ s ___ t ___ u ___

v ___ w ___ x ___ y ___ z ___

Alphabet 17 Uppercase

START
TRACING!
↓

Try this flourished
alphabet on:

- GIRLY BIRTHDAY
 INVITATIONS
- BIBLE VERSE
 LETTERING
- MUGS
- PHOTO FRAME MATS

A B C D E
F G H I J
K L M N O
P Q R S
T U V W X
Y Z

Alphabet 17 Lowercase

START TRACING! ↓

a b c d e

f g h i j k

l m n o p

q r s t u v

w x y z

Draw Your Own!

A _____ B _____ C _____

D _____ E _____ F _____ G _____

H _____ I _____ J _____ K _____

L _____ M _____ N _____ O _____

P _____ Q _____ R _____ S _____

T _____ U _____ V _____ W _____

X _____ Y _____ Z _____

Draw Your Own!

a ____ b ____ c ____

d ____ e ____ f ____ G ____

h ____ i ____ j ____ k ____

l ____ M ____ n ____ o ____

p ____ q ____ r ____ s ____

t ____ u ____ v ____ w ____

x ____ y ____ z ____

Alphabet 18 Uppercase

START TRACING!
↓

Try this pretzel-esque alphabet on:

- QUIRKY MENU SIGNS
- **THANK YOU NOTES**
- HAND-LETTERED PRINTS
- LOGO DESIGNS

A B C D E F
G H I J K L
M N O P Q
R S T U V
W X Y Z

Alphabet 18 Lowercase

START
TRACING!
↓

a b c d e f
g h i j k l
m n o p q r
s t u v w
x y z

Draw Your Own!

A _ B _ C _ D _

E _ F _ G _ H _

U _ J _ K _ L _

M _ N _ O _ P _

Q _ R _ S _ T _ U _

V _ W _ X _ Y _ Z _

Draw Your Own!

a _____ b _____ c _____ d _____ e _____

f _____ g _____ h _____ i _____ j _____ k _____

l _____ m _____ n _____ o _____ p _____

q _____ r _____ s _____ t _____ u _____

v _____ w _____ x _____ y _____ z _____

Alphabet 19 Uppercase

START TRACING!
↓

Try this elaborate alphabet on:

- MONOGRAMS
- LOGO DESIGNS
- ELEGANT THANK YOU NOTES
- WEDDING INVITATIONS

A B C D
E F G H I
J K L M N
O P Q R
S T U V
W X Y Z

Alphabet 19 Lowercase

START
TRACING!
↓

a b c d e

f g h i j

k l m n o

p q r s t u

v w x y z

Draw Your Own!

A _____ B _____ C _____

D _____ E _____ H _____ G _____

H _____ I _____ J _____ K _____

L _____ M _____ N _____ O _____

P _____ Q _____ R _____ S _____

T _____ U _____ V _____ W _____

X _____ Y _____ Z _____

Draw Your Own!

A ____ b ____ C ____ d ____

e ____ f ____ g ____

h ____ i ____ j ____ k ____

l ____ m ____ n ____ O ____

p ____ q ____ r ____ S ____

t ____ u ____ v ____ w ____

X ____ y ____ z ____

Alphabet 20 Uppercase

START
TRACING!
↓

Try this refined
alphabet on:

- WEDDING
 INVITATIONS
- **ANNIVERSARY GIFTS**
- SOPHISTICATED
 THANK YOU NOTES
- PHOTO FRAME MATS

A B C D E
F G H I J
K L M N O
P Q R S
T U V W X
Y Z

Alphabet 20 Lowercase

START TRACING!
↓

a b c d e

f g h i j k

l m n o p

q r s t u v

w x y z

Draw Your Own!

A ___ B ___ C ___

D ___ E ___ F ___ G ___

H ___ I ___ J ___ K ___

L ___ M ___ N ___ O ___

P ___ Q ___ R ___ S ___

T ___ U ___ V ___ W ___

X ___ Y ___ Z ___

Draw Your Own!

a _____ b _____ c _____

d _____ e _____ f _____ g _____

h _____ i _____ j _____ k _____

l _____ m _____ n _____ o _____

p _____ q _____ r _____ s _____

t _____ u _____ v _____ w _____

x _____ y _____ z _____

create your own unique alphabet!

Use the boxes to design your own unique set of letters!

A

a

B

b

C

c

D

d

E

e

F

f

G

g

H

h

I

i

J

j

K

k

L

l

M

m

N

n

O

o

P

p

Q

q

R

r

S

s

T

t

U

u

V

v

W

w

X

x

Y

y

Z

z

create your own unique alphabet!

Use the boxes to design your own unique set of letters!

A | a | B | b | C | c | D | d

E | e | F | f | G | g | H | h

I | i | J | j | K | k | L | l

M | m | N | n | O | o | P | p

Q | q | R | r | S | s | T | t

U | u | V | v | W | w | X | x

Y | y | Z | z

Yay Art!

Now that you've seen how many possibilities await you with hand-lettered alphabets, I wanted to treat you to some finished art. Following are four designs I created in full color, printed on nice, heavy cardstock. They are ready to be removed from the book and hung on your wall or gifted to a friend—or you can do whatever you want to do with them. You can even add doodles or otherwise customize them. They are pieces of art for you! I hope you like the four pieces I chose.

We won't be distracted by comparison if we are captivated by purpose.

Bob Goff

the main thing is to keep The main thing The main thing

ADD a Little CONFETTI to each day

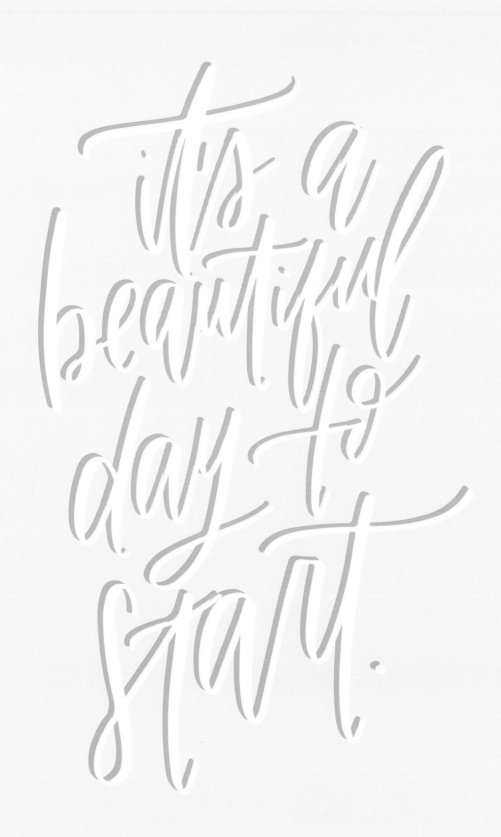

Projects

You've traced, you've practiced, you've been inspired, and you've experimented. Now it's time to actually use your new lettering skills on some stellar, stylish projects. I've come up with five awesome, easy-to-execute ideas into which you can incorporate hand lettering. Gather your supplies, decide on the lettering styles you want to use, and start wowing yourself and others with your gorgeous results!

Cute Custom Clipboard

This project is not only fun, but also functional! I love using my custom clipboard to hold documents and papers I need to keep together in my office. It definitely makes the boring stuff a little more exciting. This project would also make a great personalized gift for a friend starting a new job. Personalize the lettering to fit any kind of job or personality.

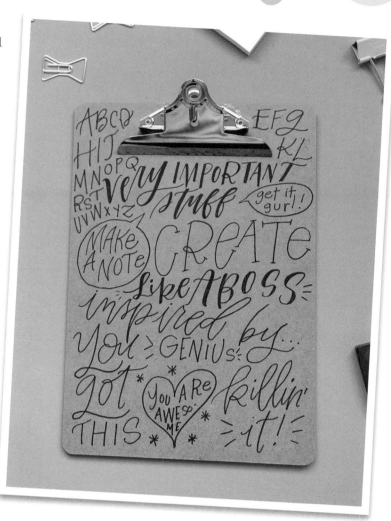

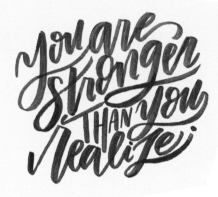

After you make a custom clipboard, you'll be dying to customize other office supplies!

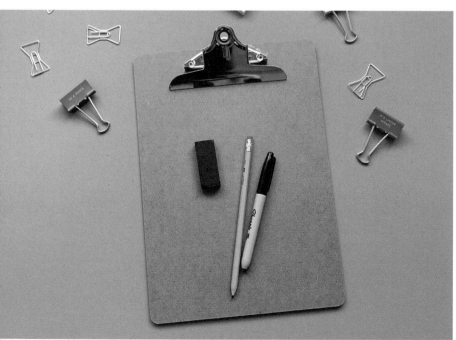

Materials

* Standard clipboard with a matte surface

* Pencil

* Permanent marker—darker colors show up best on standard brown clipboards

* Eraser

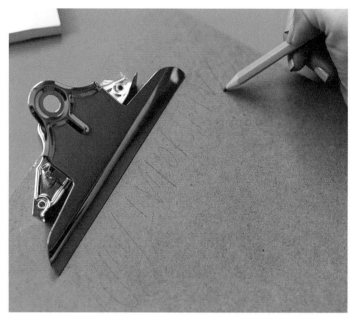

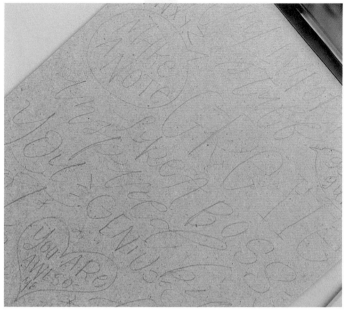

1 **Start lettering.** With a freshly sharpened pencil, begin by sketching some quotes, phrases, and other inspirational words onto the surface of the clipboard. Regular graphite will be somewhat difficult to read on a brown clipboard; you could also use a chalk pencil, but test it on the back first to make sure you will be able to erase it later.

2 **Cover the clipboard.** Letter (and doodle, if you want!) until the clipboard is covered edge to edge with lettering. Make any last adjustments to letters and spacing before breaking out the permanent ink!

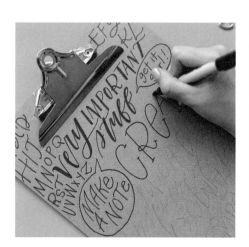

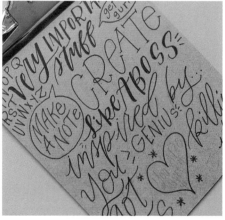

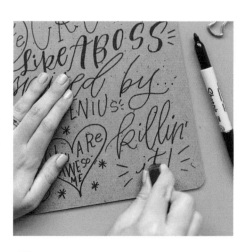

3 **Start inking.** With a permanent marker, begin tracing the pencil sketch carefully. Go slowly, as this ink will not erase! Slow and steady wins the race and gives you the cleanest results.

4 **Finish inking.** Complete all the inking; you can still modify some letters if you choose at this stage. I chose to do a regular monoline lettering style for most of this project, but I played around with some faux calligraphy to add some interest.

5 **Erase.** Give the ink a moment to dry—check by lightly touching it with your fingertip—before going in with an eraser to clean up any remnants of your original pencil sketch. The pencil marks will erase easily, leaving with you with a clean and sassy surface.

Mat Memories

This project doubles as a fun way to preserve memories and as a really incredible gift idea! You will impress your loved ones with your awesome lettering skills while giving them a thoughtful gift they will display for years to come.

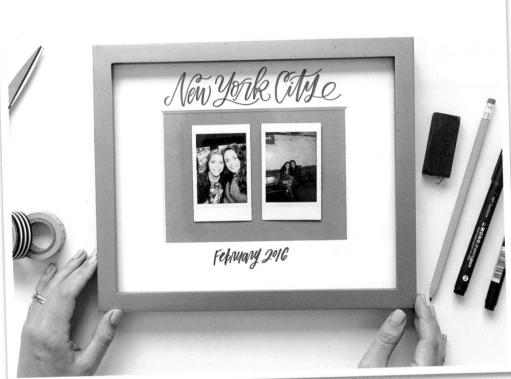

The hardest part is to decide where you'll display your customized mat and the memories inside!

Materials

* **Photo frame mat in the size and color of your choice**
* **Pencil**
* **Brush pen**
* **Fine tip pen**
* **Eraser**
* **Washi tape or basic tape**
* **Scissors**

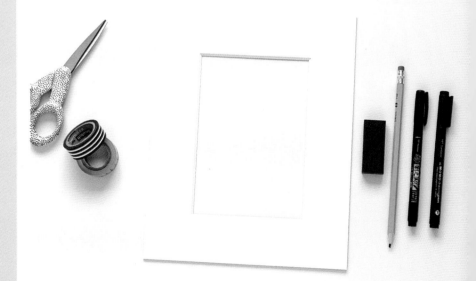

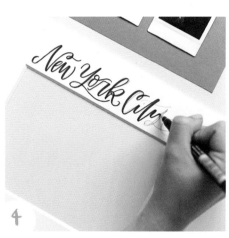

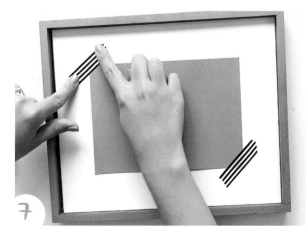

1 **Start lettering.** Begin by lightly sketching your lettering onto the surface of the mat. Sketch lightly so that you can go back over it if you need to make adjustments and still be able to erase cleanly. I decided to go with a cutesy script for this project.

2 **Adjust the lettering.** Go back over your letters to make sure you are happy with them before proceeding with inking. I traced back over my pencil sketch to make sure my lettering suited my vision for this project.

3 **Start inking.** Going slowly, begin tracing your sketch with a brush pen. I love using a small nib brush pen for delicate projects like this one!

4 **Ignore mistakes.** Don't worry about making little mistakes like slightly uneven lines. The surface of the mat may be a little textured, but we will clean up minor mistakes later.

5 **Erase.** When you've completed inking, give your project a few seconds to dry. Then, take your eraser and lightly erase all signs of graphite pencil.

6 **Fix mistakes.** Grab a fine tip pen and carefully fix any uneven ink edges. Go slowly during this step so that you don't accidentally make a problem worse!

7 **Assemble the photo frame mat.** Place your finished mat inside your picture frame. You can tape down your photo to ensure it stays put.

Make Your Own Mug

Yet another awesome gift idea, hand-lettered mugs are just plain fun to create! If you want to use the mug for drinking, make sure the mug is oven-safe so that you can "cure" the ink to make it food-safe and washable. Also make sure you use oil-based paint markers rather than normal permanent markers—only oil-based paint markers will set correctly and safely in an oven.

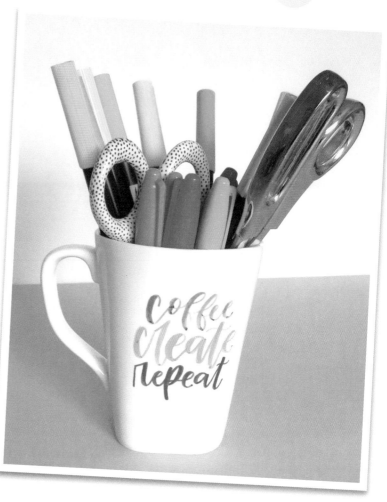

Everyone will be jealous of your custom mug and beg you to make one for them!

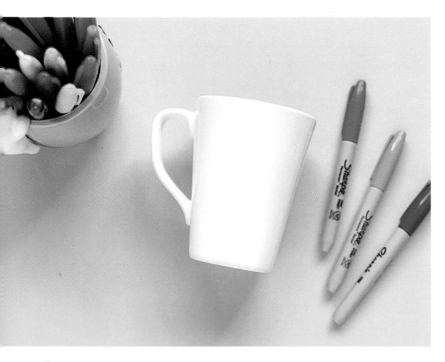

Materials

* **White or light-colored ceramic mug**

* **Permanent markers—normal markers to make non-food mugs, or oil-based paint markers to make food-safe mugs**

* **Paper towel**

* **Water (for normal markers) or rubbing alcohol (for oil-based markers)**

* **Oven (to make food-safe mugs)**

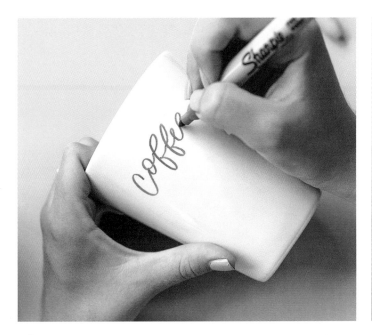

1 **Start lettering.** Grab a marker and start writing! Don't worry about sketching for this project—you can wipe away any mistakes with a damp paper towel if you do it immediately, so keep one on hand. Remember to go slowly and take your time for clean, straight lines.

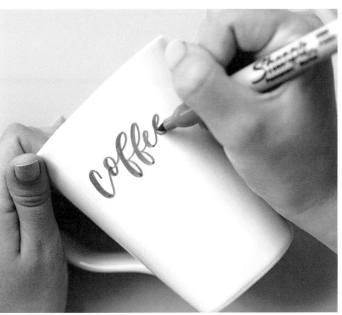

2 **Modify the lettering.** Go back and modify or clean up your first finished word. For this project, I chose to do faux calligraphy. After writing out each word on my mug, I thickened the downstrokes by adding another line.

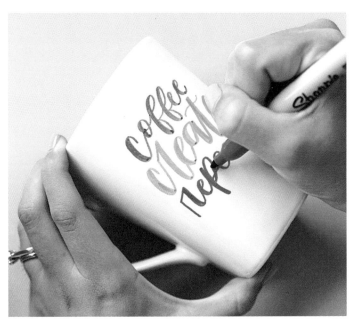

3 **Finish lettering.** Move onto your next colors and words. If you want to also add doodles, you can! I stuck with a simple three-word design this time. Note that because I used normal permanent markers, I'm not planning to use this mug for drinking and won't be putting it in the oven to set the ink.

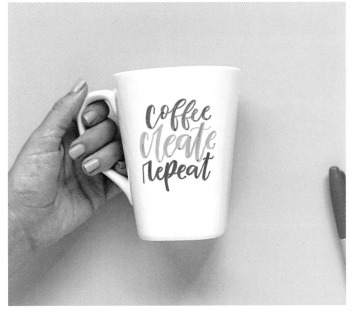

4 **Finish the mug.** When you are happy with your design, you get to decide what to do with it. If you used oil-based markers and the mug will be used for drinking, you will want to let the mug dry overnight, then bake it in the oven at 350°F (180°C) for 30 minutes to seal in the ink. But please double check to make sure the particular markers and mug you used will bake correctly and safely. Hand wash only for lasting results! And don't worry about baking your mug if you plan to just display it in your creative space or use it to hold office supplies.

Sweet & Simple Thank You Note

I send a lot of thank you notes, so it only makes sense to create my own! Hand lettering the sentiment on the front makes a thank you note that much more thoughtful. I'm going to show you a simple technique for creating two different display-worthy thank you notes.

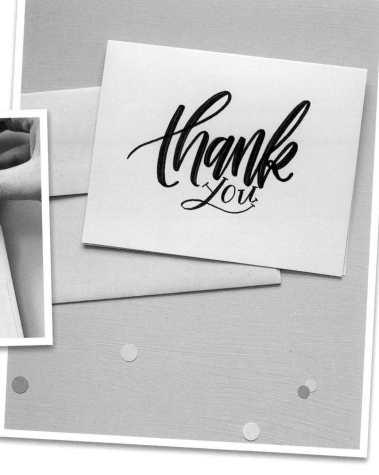

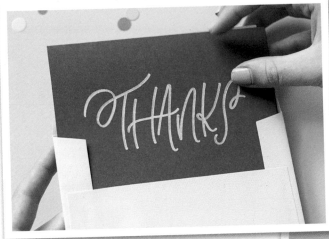

Custom thank you notes don't take long to make, but their recipients will appreciate your heartfelt effort.

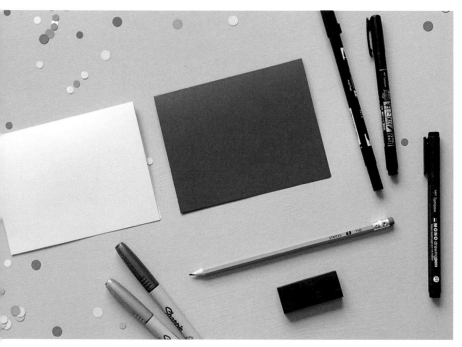

Materials

* Blank cards
* Pencil
* Eraser
* Brush pen
* Fine tip pen
* Metallic pens

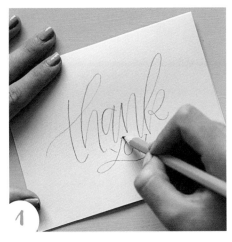

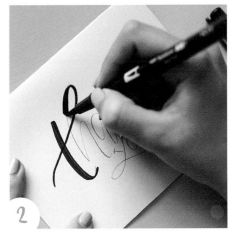

1 **Start lettering.** Begin lightly sketching your lettered design onto the front of a blank card. For my design, I paired two lettering styles together in a mix 'n' match format: "thank" is in a traditional script style, and "you" is in a serif design.

2 **Ink the main word.** Begin tracing your sketch with your brush pen. I used a large brush pen for this large main word. Remember to go slowly! And don't panic—you can always start over if things don't go as planned.

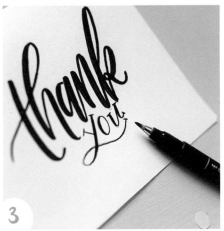

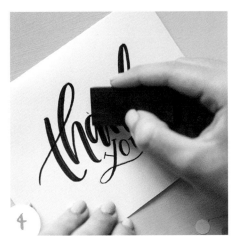

3 **Ink the smaller word.** Trace the smaller word. I used a small brush pen for this. Using two different pens will create a dramatic difference in the two words. I absolutely love how elegant this looks and how simple it was to achieve!

4 **Erase.** Erase all remnants of your pencil sketch with an eraser.

5 **Clean up.** Use a fine tip pen to go over any uneven lines. Using a fine tip pen to clean up rough edges like this is my secret weapon for excellent lettering on the "first" try (wink!).

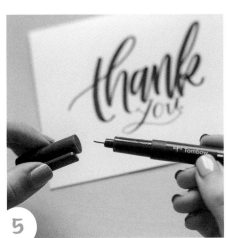

Try another look! You can also make a card using dark paper! Follow the same steps, but use a pretty metallic pen that will stand out against the dark cardstock.

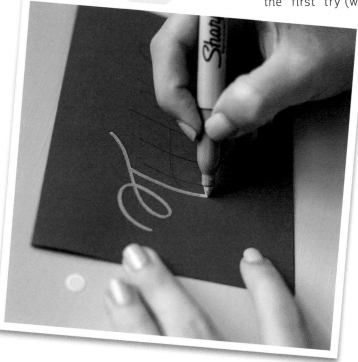

Fancy Paper

Jazz up plain wrapping paper with some simple lettering and bring the cutest gift to the party! It is so refreshing to use simple colored paper with a hand-lettered design instead of buying the same gaudy wrapping paper that's always sold in stores.

Your gift will stand out in the crowd!

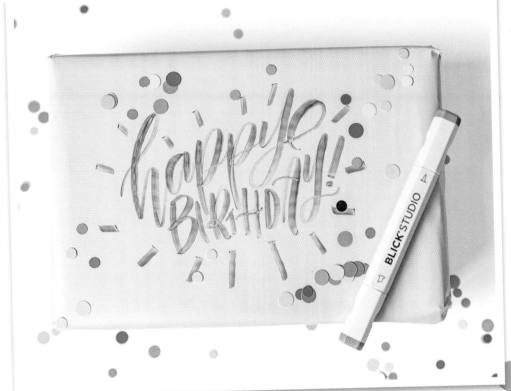

Materials

* **Wrapped present**
* **Pencil**
* **Brush pen or permanent marker**
* **Eraser**

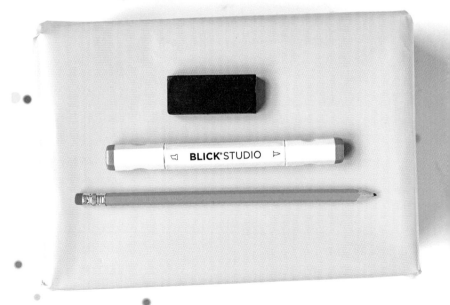

1 **Start lettering.** Begin lightly sketching your design onto the surface of the wrapping paper. I find it works best to sketch on an already-wrapped gift. Because you already wrapped the gift, take a little more care not to make too many mistakes once you get to the inking stage. But don't worry about it when doing your pencil design!

2 **Choose your marker.** I love using Copic markers for various projects because of their thick brush nibs. For this gift, I chose a gray color to complement my light blue wrapping paper, but it would also be so fun to change it up with some bright colors!

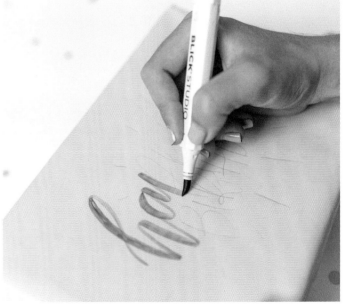

3 **Ink the lettering.** Begin tracing your pencil sketch slowly with your brush pen or marker.

4 **Finish the lettering.** When you've completed your lettered design, give it a couple of minutes to dry—the wrapping paper surface could prevent the ink from drying as quickly as normal. Erase any remnants of your original pencil sketch very carefully.

Practice makes progress

Practice makes progress

Index

Note: Page numbers in *italics* indicate projects.

TRACING PAPER STARTS HERE!

Tear these sheets out along the perforation, and then use them to practice tracing alphabets and other lettered designs throughout the book.